ALICE IN THE MUSEUM OF WONDERS

Discover with me the Pio Christian Museum in the Vatican

Elisabetta Putini - Costanza Baccani

ALICE IN THE MUSEUM OF WONDERS

Discover with me the Pio Christian Museum in the Vatican

illustrations by
Lara Artone

EDIZIONI MUSEI VATICANI

© 1999 Office of Publications and Reproductions of the Vatican Museums
Printed by Tipografia Vaticana
Translated by Sabina Castelfranco

ISBN 88-86921-64-0

INDEX

YESTERDAY

TODAY

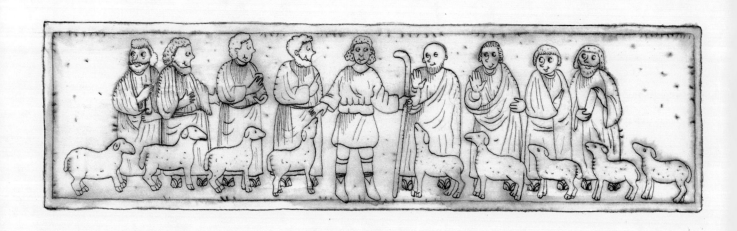

A special man called...

He may be the most famous man in the world. And yet his life was very short: it lasted less than 40 years! It began in a grotto in Bethlehem... It was the night of the angel and the pastors. What a night! We still remember it today, every year, as an extraordinary event: a Jewish baby and his parents were gathered together; they were cold and very poor, enveloped by the enchantment of birth. A moment of intimacy that was to change the world! Can you imagine it?

Everything began that night... That boy grew up, like a tree with its many branches and leaves. It was the divine tree, which was to sacrifice its wood and its leaves to save mankind. And so, after a very intense life, of preaching, miracles, care and love for others, that special man kept his promises. How? In a way that can be difficult to understand.

He had his last supper with his closest companions. He accepted to be betrayed, humiliated, reneged; finally he was judged and sentenced to death. And so that special man went up Mount Calvary and was nailed to a cross, suffering from his wounds until he could bear it no longer... and he died to save the world. But here is the extraordinary event: he resurrected and ascended to heaven and those who were his companions were able to see him, continue to follow him and understand his secret message. Do you want to try too? That special man called Jesus was like a divine tree... and his roots have been growing for nearly 2000 years. They are the largest and strongest roots in the world. Growing across the earth, they have given life to an important story which has changed the course of history. Christianity was born.

The origins of a key word

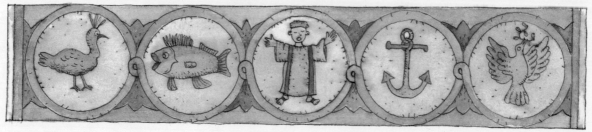

Have you ever asked yourself where the word Christianity comes from?
It comes from the Greek χριστός (read *cristòs*), which means "anointed", "chosen by God", "consecrated". The ancient ceremony of anointing, during which the forehead was marked with oil, is also part of our baptism.

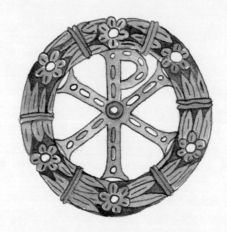

And Jesus, also called Christ, is the son of God, the special man who brings to all people the sign of this consecration. His message, which after him becomes known as Christianity, spreads quickly and becomes a starting point and reference for history.

Two books... in one

L. Artone

Divine presence in the world is something that you can "see" every day in the beauty and perfection of nature or which you can "feel" within yourself. But this presence is also witnessed, explained and narrated by two ancient collections of very special books: the Old and the New Testament.

If you are curious, you'll want to know what these important books are about. Here's your wish fulfilled! The Old Testament is the collection of the 45 books sacred to the Jews: the exciting and extraordinary story of this people, accompanied in their journey by an alliance with God.

The new Testament includes the story of Jesus' life, of the new alliance reached between God and men and the writings of the Apostles. Jesus, a descendant of the Jewish people, gives life to a new alliance, which changes that of his family and his people. Christian religion has its origin in the Jewish religion; it's the continuation of it and has kept one of its fundamental characteristics. Which one? Try to compare these two religions with the others that spread in ancient times. Think for example of the Egyptians, the Greeks, the Romans... who adored so many deities.

And here's the big difference: the Jews and then the Christians believe in only one God. Christianity continues the alliance which God made with the people of Israel. The new alliance is not for just one people, but for all peoples; for men of all cultures, of all continents and all eras.

The Old and New Testament together thus become the Bible of Christians, in one word the sacred book of the new alliance.

The Gospel becomes famous

What role does the Gospel have in the Bible of Christians? The Gospel is the newer and more revolutionary central part of the book: it means "the good news" and, in the book's plot, it introduces the key character, that special man who is prepared to live and die for all men: Jesus.

His life, his ideas and his teachings are told by four exceptional story-tellers, who gather the information and narrate the main events. The story-tellers then sign the four Gospels. Yes, they are the famous evangelists: Matthew, Mark, Luke, John.

A few years after the death of Jesus, Christianity has already spread. Starting from Palestine and Asia Minor, his message instantly crosses geographic boundaries, extends to Greece, crosses the sea and reaches Rome, the political centre of the empire.

And the Gospel soon becomes famous and well-known.

If you're asking yourself the reason behind this vast circulation, there are many. To start with, persons such as the Disciples carry out a formidable activity of preaching in the cities and eastern villages. Their work is similar to that carried out today by mass media, that is, the current means of spreading information. Among these preachers, Paul of Tarsus, a Roman citizen and Jewish by birth, plays a fundamental role. Paul, a persecutor of Christians, converts to Christianity. Then, for about 30 years, he travels continuously across the most important eastern provinces of the Roman Empire, preaching the Gospel; but he is arrested and taken to Rome to be tried... Here he undergoes

martyrdom in the first significant persecution against Christians during the reign of Nero. The Roman Empire, without intending to, supplies the Disciples with an extraordinary system of streets and ways of communication, which link eastern and western lands under the control of Rome. Thanks to these roads, which have resting areas and provide for the change of horses, long distance travelling becomes possible. But the Gospel does not only spread because it uses a good communication network and many excellent messengers! It's mainly the content of its message which affects those who hear it. A very new message of love for all, rich and poor, which rejects slavery and rewards faith in another life.

The Roman Empire produced power and wealth, but also inequality, slavery, poverty. For a huge number of people there is no hope. But the Gospel offers everyone a hope, which is much more than social and economic security: it's the announcement of eternal salvation for all men of good will. How could one refuse to listen to it?

Once in Rome, the Christian phenomenon is at the heart of the empire. The faith is cultivated within the family nucleus: it's enough for one Roman citizen to convert that all his family members follow suit, because in Rome the "head of the family" has a very strong authority, which also extends to servants and relatives.

These first Christian families host meetings, rites and common prayers. In this way houses become the places to meet with other Christian families, small "domestic churches" where baptisms and the last supper of Jesus are celebrated. Jesus himself said it after the last supper: do this in memory of me.

The arrows of time

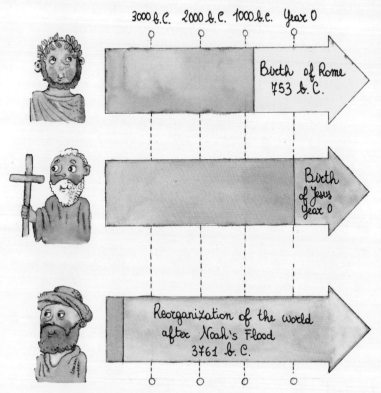

3000 b.C.　2000 b.C.　1000 b.C.　Year 0

Birth of Rome
753 b.C.

Birth of Jesus Year 0

Reorganization of the world after Noah's Flood
3761 b.C.

Today, in many countries of the world, the birth of Jesus is taken as a reference to start counting the years. This is the "Christian" calendar and the year in which Jesus was born is considered the beginning, that is year zero.

For this reason, when books tell ancient stories, they use the abbreviation b.C., which means "before Christ" and A.D., which means after Christ (from the Latin *Anno Domini* for "year of our Lord"), to indicate events which took place before or after his birth.

What day is it today? Of which year? If you take a look at your calendar, you are able to answer immediately. But if someone asks you: "which era are you living in?" that's where the doubts begin… And yet it's simple: you live in the second millennium of the Christian Era.

But before the Christian era began and before the spread of the calendar you are familiar with, there were many other ways to count the years, different ways for various peoples (for example, the Romans and the Jews).

Let's go and discover the arrows of time!

Why against Christians?

The Roman empire comprises many religions, very different from the local one and allows foreign conquered peoples to build their own temples and practice their own cults. Why not allow Christians to do the same?

But then something changes... Christian ideas are spreading too quickly. The message of equality, fraternity and love of the Gospel starts to worry the Roman government because the empire is based on class differences, slavery and the great power of the emperor... That message is a real threat to internal order... What to do? At this point an extraordinary event occurs...

It's the year 64 A.D. and Nero is the Emperor. According to Tacitus - a famous Latin historian - a sudden and violent fire breaks out in Rome. In nine days the city is destroyed! Many think that the Emperor, who has already given the first signs of madness, is responsible for that disaster!

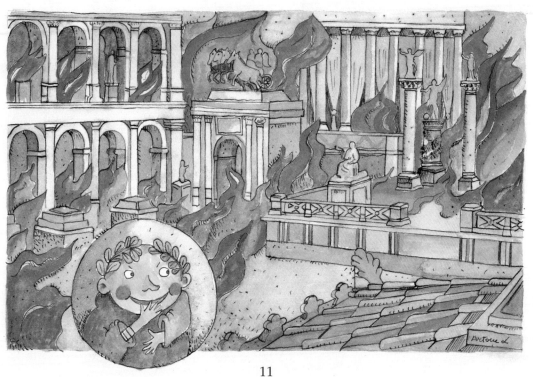

And so, to put an end to all those rumours, Nero tries to find a "scapegoat": he points to the Christians as those responsible for that fire and orders that they be arrested and sentenced to death. There are no clues, there is no evidence... but the accusations of the Emperor are enough... because he is the state's highest authority!

That's how the first major persecution against Christians begins. According to the tradition, the victims of that persecution include Peter and Paul: Peter is crucified in the circus of Caligula, below the Vatican hill, and Paul is decapitated outside the city walls and buried where a large basilica named after him stands today.

For the whole of the I, II and III century A.D. many emperors continue to more or less violently oppose the spread of Christianity. After the first one, the fiercest persecutions are ordered by Domitian, Decius, Valerian, until the last one wanted by Diocletian.

Despite this, the new religion spreads undeterred, penetrating the upper social classes, among nobles and even among soldiers and state officials.

If you are asking yourself how come the persecutions help faith spread instead of discouraging conversions, you can find one of the answers in the example of the martyrs: their faith has an effect and attracts.

Martyrs die serenely, without reneging their faith: thus they become witness that those ideas have great value and are the right ones, and they are able to defeat the fear of torture and death!

Christianity gains greater strength through the martyrs; their tombs become sacred sites where the faithful meet to pray and celebrate mass. The most important Roman basilicas were built on some of those tombs, outside the city walls.

A frightening show...

The violent death of the first Christian martyrs is often a spectacular event. It is a frightening show, with a horrifying blood-drenched scenery. Executions, according to what is decided by the emperors, must serve as an example for the others condemned: to be saved, you need only deny being a Christian and renounce the faith.

During the Roman Empire, games, competitions and shows attracting huge crowds are often held in the circus and amphitheatre. In the most famous amphitheatre in Rome, the Coliseum, among the various programs there are some which are truly shocking and cruel, such as the gladiator fights. But, contrary to what is believed, the Coliseum is not where the majority of Christian martyrs are killed. In fact, it is the circus, built for the races and horse and cart competitions, that becomes the main site of death for Christians. The circus is the shape of a very long rectangle, and one of its two shorter sides is a semi-circle. At the centre of the rectangle is the ridge, a long small hill bordered by a wall, around which competitions are held among the dust of the carts and the noise of the horse hooves.

During the persecutions, the crosses of the martyrs are erected along the very wall of the ridge.

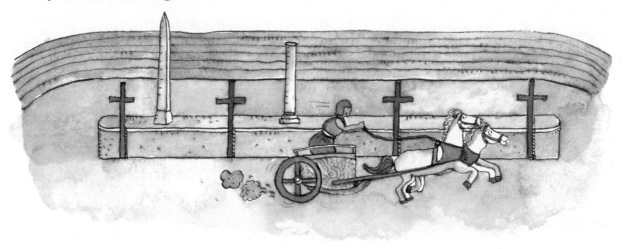

Nero himself orders that death sentences be carried out in the Circus of Caligula. And in that circus (which then became famous as the Neronian Circus) is where Peter's martyrdom takes place. He is not buried far from there. Today the Circus of Caligula no longer exists: but on the site of Peter's tomb, Emperor Constantine builds a basilica dedicated to the martyr.

Some stories tell of the most bloody and cruel ways of martyrdom, terrible tortures and macabre shows of death: many condemned are fed to the beasts; or burned alive, like Saint Lawrence, or decapitated, like Saint Paul, or covered in arrows, like Saint Sebastian.

Popular fantasy may have exaggerated! But at the origin of those tales is the true story of martyrs: men and women who, conquered by Jesus, considered their love for him stronger than the defence of their own lives.

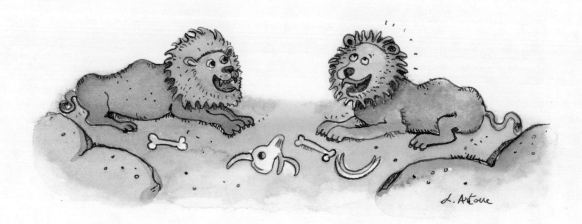

A sigh of relief...

It may seem strange, but it was an emperor who in the end officially resolved the religious problem of the Roman Empire. It was Constantine, who was in power between 306 and 337 A.D. A famous legend goes like this...

It's the night before the battle of Ponte Milvio and Constantine cannot fall asleep. Finally he falls into a restless sleep... And then, suddenly, the cross appears before him in his dream... and a faraway voice reassures him: *with this sign you will win!* At dawn Constantine is ready for battle: on his standard he has substituted the imperial sign with a large cross. And his battle ends in victory!

Of course, this episode may be only legend... but the emperor really does resolve the problems of relations with Christians. At a time of divisions and great political disorder, Constantine understands the growing importance of the Christian community in Rome, he recognises the authority of the bishop and donates some land to the Church so that it 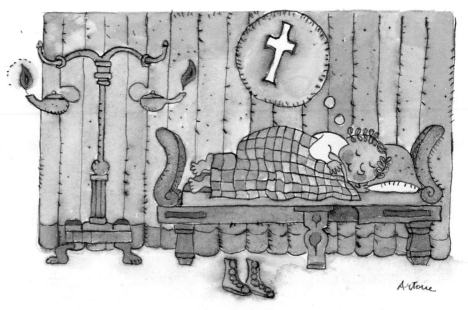 may flourish. But above all he grants Christians religious peace. For the first time in 313 A.D. Christianity conquers a clear position in the empire. A few years later, in 380, comes a real sigh of relief: Emperor Theodosius proclaims Christianity the state's official religion.

So many tunnels under the city

The first Christians bury their loved-ones in open cemeteries (necropolis) along with people of different faiths; in accordance to the laws of Rome, the graves are placed outside the city walls.

Then the Christian community begins to grow and even rich and noble families convert to the new religion. And so, especially the upper classes have graves built on land of their property. Finally, from the first half of the III century up to the V century A.D., Christians prefer underground burial to open-air burial: here they rest with other Christians, united in the sleep of death. That's how they open many underground passages or use already existing tunnels. That's how the Catacombs come to be: at the beginning they are only places of burial and, later, they are places of prayer. Kilometres and kilometres of tunnels are excavated by special workmen, provided with pawls, axes and hoes: the diggers. Dressed in short tunics without sleeves, and a cone shaped cap on their heads, these workmen live with the offers of the

faithful and also have the task of burying the dead. But theirs is a really tiring and dangerous job.

Sometimes the diggers excavate superimposed corridors, at various levels, which in some cases are over twenty metres below the surface, like an upside-down building which goes down for a good three floors. And loculi are dug in the walls of the tunnels.

The body of the dead is placed in the loculus, which is then sealed off with a marble or terracotta slab, on which is engraved the name, sometimes the age and a phrase such as *rest in Peace*. And for those who don't know how to read or write? A symbolic drawing is needed (an anchor, a fish, etc.) to be able to recognise that grave, or it is enough to attach a small object of the dead person to the slab, such as a small doll, a coin, a shell or a piece of painted glass.

Dedicated to...

Roman law establishes that the land below belongs to the same owner of the land above. For this reason many catacombs are excavated beneath the land belonging to noble Christian families and are often named after them. Not only, sometimes the catacombs are also named after the martyr who was buried there. For this reason the tunnels expand into spacious rooms, which (from the V century A.D.) are used for the cult of martyrs.

The catacombs of Domitilla (on the Via Ardeatina) are named after the noble Roman woman who owned the vast land below which they are located. One day when Domitilla decides to free all her slaves, she gives them that land.

The catacombs of Priscilla (on Via Salaria), occupy the site of the old quarry of pozzolana, a rock of volcanic origin. Priscilla is also a noble Roman woman, who descends from a family of senators.

The catacombs of St. Sebastian, (on Via Appia) are dedicated to the martyr of the same name, who was well-known and venerated. According to a popular legend which circulated in ancient times, Sebastian was a young officer of Emperor Diocletian; one day he was accused because he was a Christian and condemned to the martyrdom of arrows. Despite being pierced, Sebastian doesn't die; so he is beaten to death and thrown into a sewer. His body is then recovered and buried here.

The catacombs of St. Callistus (on the Via Appia) are named after Pope Callistus I, administrator and custodian of the first Christian cemetery.

At the end of the V century, the cemetery was transformed into a popular shrine visited by large numbers of pilgrims. If you visit these catacombs today, look for a famous inscription in which for the first time the term "Pope" is used to indicate the Bishop of Rome.

The catacombs of Saints Marcellinus and Peter (on Via Casilina) are where the pagan cemetery of the emperor's guard was located. Then, in the III century, the Christian catacomb is built, housing the bodies of many martyrs; among these the most famous are Marcellinus and Peter.

The catacombs of St. Agnes (on Via Nomentana) are dedicated to a young martyr, Agnes, who died when she was only twelve years old during the persecution of Diocletian, and was buried here.

A strange post office

Surely you already know that figurative art is the oldest form of communication and is of easy comprehension.

This is why the first Christians entrust to painting and sculpture the task of communicating their ideas, of transmitting their religious message. A message with symbolic shapes and images; the symbol, in fact, is a way to simplify a concept. But there is more. The first Christians do not yet have their own artistic tradition; and so they are inspired by the pagan, Greek and Roman traditions which made great use of symbols.

In addition, in the Roman era both paintings and sculptures are created by artists who worked without distinction for pagan and Christian clients. These artists had their own style, decorative models which they did not give up. And so they often mixed old and new elements, Christian symbols and pagan themes. The typical themes and techniques of pagan art are also re-elaborated and transformed: thus, art becomes the spokesperson of a different, new and deeply Christian message. A message made of symbols and story-symbols.

Christian symbols always conceal a meaning; often there is more than one… And so a "bag" full of messages is leaving this strange post office: they are the messages of a special symbolic art which spreads religious ideas not only through preaching, but also through painting and sculpture.

Fish, peacocks and other animals...

A little word of advice: if you visit a Christian catacomb, take a flash light with you and shine it on the walls, the ceilings, between corridors and dark cubicles. You will discover many things...

You will see paintings which show techniques, colours and decorations typical of the Roman tradition, but the themes are different. They are frescoes which were painted by torch light on the fresh layer of plaster which covers the walls. In this way the layer fixed the colours as it dried.

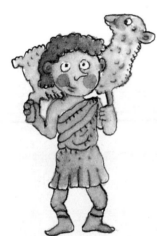

Which are the most common symbols in Christian fresco paintings? There are many, but one is more common than the others: the figure of the Good Shepherd, carrying a lamb on his back. The shepherd symbolises Jesus who looks after his flock, that is, the Christian community; and the lamb? It's the lost lamb of the famous parable, that is, people who have distanced themselves from God. But Jesus seeks them out and brings them back to the flock.

Another recurring figure is the fish, a popular symbol for Jesus. Just think, the letters of his name in Greek represent the initials "Jesus Christ Son of God Our Saviour".

Even the anchor is a Christian symbol: it represents safety, salvation in a safe port.

And the dove? It's often depicted with an olive branch in its beak. Still today it brings the message of renewal through baptism, like the rain of the Flood renewed humanity.

The peacock, for its beauty, is a sacred animal to the goddess Juno, and, according to an ancient legend, is considered immortal by pagans. And so Christians also represent it as a symbol of the soul which rises anew.

There's yet another mythological bird which becomes important for Christians: the phoenix. It has a strange tuft on its head and a very long life. But, when it feels death coming closer, it builds a nest for itself which becomes its pyre: there it burns and then comes back to life from its ashes. A true symbol of resurrection!

The orator in prayer is a figure with arms raised and hands turned up towards the sky. You can often see it in the frescoes: it is the symbol of the soul which has received eternal salvation.

A message in stone: the sarcophagus tells a story...

Sculpture also transmits many messages. You can read them in the decorations of the ancient Christian sarcophagi. The most important ones are made in Rome during the III and IV centuries A.D. They are still in Rome today, especially in the Pio Christian museum in the Vatican.

The sarcophagi were rich graves, for the use of well-to-do or well-known figures who could afford this luxury!

They are true and proper coffins in sculpted marble, found in Christian cemeteries, in mausoleums, in cemeterial basilicas or, more rarely, in catacombs. The body of the deceased was kept inside. Sometimes, in the larger sarcophagi, there were two bodies, often a husband and wife.

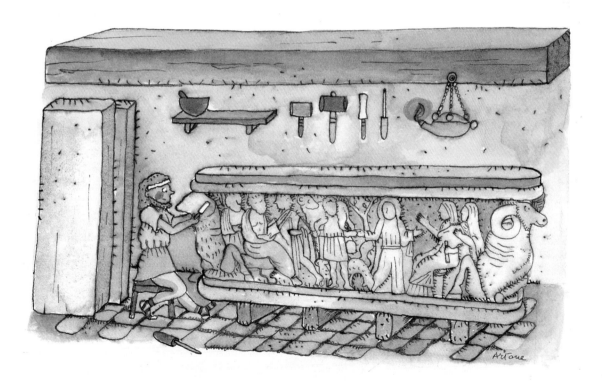

Families ordered their sarcophagi from craftsmen who specialised in stone and marble: marble workers.

Marble workers in Rome always have clients and work hard! Some have emigrated to the capital from eastern provinces. They don't earn very much because their salary is low. But they love their job and they pass it on from father to son. Unfortunately we do not know their names because they were not in the habit of "signing" their work.

The marble workers' stores were mainly located along Via Marmorata (which is still called the same today), near the large port on the Tiber, where ships laden with blocks of marble arrive from the sea travelling up the river.

If you're asking yourself how these sarcophagi produced by the marble workers are constructed, here is a description and some advice: read it but then go in person to see them because they have many stories to tell.

The sarcophagi are shaped like oval tubs or rectangular coffins sealed with a lid cover, with two pitches, or otherwise with a flat slab. The decoration on the front can be distributed on one or two levels, called registers. The figures in marble can be in low relief, that is, not very detached from the base, or in high relief, which really seem to "escape" from the marble!

The decorations include a crowd of figures, many natural and architectural elements, which are often used to separate the scenes represented. There are small columns, capitals, whole arches, split arches and then those strange strigilated panels with many big S's which resemble the waves of the sea. Just think they're called this because they resemble the shape of the *strigil*, an ancient curved instrument in bronze (a sort of long curved spoon), which was used mainly by athletes to wipe off sand and sweat from their bodies.

Strange but true! Some parts of the sarcophagus were even painted with bright dyes, such as yellow, red, blue and gold. They were vegetal and mineral colours applied on the marble with a technique which gave a beautiful effect, but faded with time. That's why today you see them like this, colourless.

Just like the pages of a book made of stone, which tells many ancient stories! Stories of the Old and New Testament, often mixed together without an apparent order. You can see events and characters of eras so faraway and

different, represented on the same plane, as in a continuous narration, even though they seem to have nothing in common between them. However they are deeply connected because they suggest the same idea, the same message: a message of salvation.

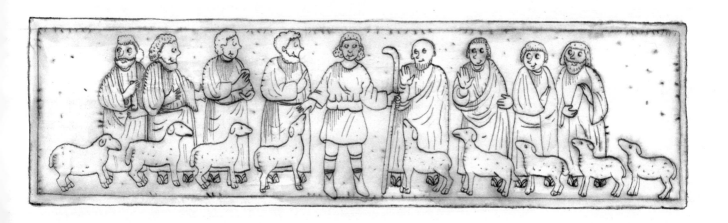

Mirtilla celebrates her eighth birthday

We are in Rome in the year 330 A.D. Mirtilla is a young eight-year old Christian slave. Even for a girl like her, life can be pleasant especially if you are the favourite play companion of the niece of a Roman senator. Just imagine that Mirtilla is lucky enough to live in a small area on the ground floor of a beautiful villa on the Esquiline Hill.

Her father has told her that over the past 17 years many great things have happened in the Roman Empire! To start with Emperor Constantine gave freedom to the Christian religion. But that's not all. This year in particular, Constantine gave a gift to the Church and consequently to all Christians and Pope Sylvester is so happy he's in seventh heaven.

Lana Artoue

This is what happened: the Emperor gave the Bishop of Rome one of his splendid buildings and is having some lavish new basilicas built on the tombs of the martyrs.

Often Mirtilla is allowed to play with the dolls of her young boss Domitilla who is the same age as her: these are more beautiful than hers because their arms and legs are double-jointed and they are not made of rags, but of bone and ivory and they have an incredible trousseau of small tunics!

26

There is no lack of time to play, especially when Domitilla is busy with her teacher, a tall man with a white beard, who speaks Greek. Her boss likes to play "teacher and student", and so she happily lends her wax tablet and stylus to Mirtilla. And she also tries to teach her to write... but with little success!

Mirtilla on the other hand is very good in the kitchen: she has learned from her mother to make honey biscuits and olive flat bread. These make Junius' mouth water, even if he always eats plenty of them at the end of his lessons. He has a sweet tooth.

Junius is Domitilla's brother. He's two years older than her and he too is taught by the teacher who comes to their home. But he is very lively and enjoys chatting and often his hands are red because of the *ferule* blows he gets because he never pays attention when the teacher is speaking.

Uncle Elias is in charge of cleaning the amphitheatre and often comes to see her from the Via Appia, even though he lives a little far. Mirtilla is very happy to see him because every time he tells her a lovely story about the many competitions that are held at the arena and even some horrible and violent stories about the gladiator fights.

In a few days there will be a beautiful ceremony for the baptism of Aunt Agnes. It was grandmother who chose that name, in memory of a young martyr. Once grandfather told her that when he was young these ceremonies where held in private homes. And so there was always a rich friend who lent his house, just like a small domestic church.

Poor grandfather, he was lucky to get away at the time of the great persecution against the Christians, carried out by that hateful emperor Diocletian, who wanted to force everyone to adore him like a god!

Mirtilla considers herself a very fortunate girl because she has never had any of these problems and sometimes she even laughs at Domitilla (who is pagan) when she takes gifts to the Lares, her ancestral protectors of the house and the family.

Mirtilla has a very dear friend, Eusebius, who is 15 years old and works in one of the many marble workers stores along Via Marmorata. When she went to see him, he was on his way back from the river port where a ship laden with already emptied and moulded marble blocks had just arrived. Eusebius is learning to sculpt them, so those blocks will become beautiful sarcophagi. Mostly Mirtilla likes the reliefs that tell stories of Jonas in the stomach of the sea monster and of Daniel in the lion's den. Oh, how scary!

The funeral of Grisogonus, a rich friend of dad's, will be held tomorrow. And so they will all go down into the catacomb together where many flickering flames light the long and dark tunnels. It's a really suggestive sight! By

28

the way, mother has told her not to forget to bring her oil-lamp and a small vase for the perfumes.

Today Mirtilla has celebrated her eighth birthday and for this special occasion her mother has woven a new, white tunic. Her cousins have come to see her and as a gift they brought her a bronze ring engraved with a monogram of Christ. Mirtilla is very happy with her gift and is always going to wear it.

In the afternoon, her bosses allowed her to go with her parents to the crypt dedicated to the martyr Sebastian, on the via Appia. There a mass was celebrated, in memory of the martyr's death. It was a beautiful event and nearly everyone was touched, especially mother, who is so devout.

After the mass, the family gathered. Grandparents, parents, cousins and Uncle Elias all ate together... as used to happen a long time ago, at the time of the first Christians. It really was an unforgettable day!

The fun pages (games and curiosities)

1) These drawings suggest two episodes: one of the Old and one of the New Testament. Match them in the correct way.

A. Old Testament..........................

B. New Testament..........................

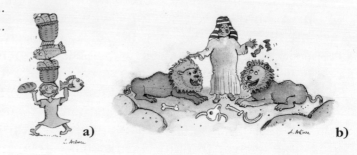

a) b)

2) Can you find two Christian symbols among the signs and the lines?

3) Mirtilla's recipe
Here's an ancient recipe often used by Mirtilla that you can use yourself: sweet bread.
Ingredients for 6:
12 slices of stale bread
1 cup of milk
12 teaspoonfuls of honey
a drop of olive oil
Soak the slices of bread in the milk, then fry (with Mother's help) in the boiling oil. Drain off the oil, then spread with honey and... your sweet bread is ready to eat!

4) Solve the crossword. The name of the most famous preacher Disciple will appear in the coloured line.

Clues:

1. One of the Christian symbols.
2. He lived in the stomach of a sea monster.
3. Many Christians suffered this kind of martyrdom.
4. An ancient religious belief against the ideas of Christianity.

a) c)

b)

5) Only one of these three drawings can remind you of a famous emperor who persecuted Christians. Discover his name.

6) Executions during the persecutions took place in only one of these three places. Which one?

 a) *Circus* b) *Temple* c) *Baths*

7) Do you remember the arrows of time? What year were you born according to:
- the Roman calendar.................................
- the Jewish calendar.................................

8) The names of two 'places' where the first Christians were buried are hidden among the letters in the square on the right.

I	N	D	E	X	O	E	U	S	I
E	G	O	S	C	C	A	P	S	N
B	H	A	C	O	R	G	D	B	T
N	O	E	H	M	D	L	U	M	E
A	S	H	F	P	E	E	S	O	R
C	T	G	A	U	O	S	T	C	N
I	H	I	I	T	Q	C	Y	A	E
T	J	L	T	E	I	E	R	T	T
A	M	N	H	R	U	T	S	A	O
V	O	P	F	A	Z	R	E	C	S

Two extravagant children

Alice in the museum of wonders

Alice is 12 years old. She's fun and somewhat of a dreamer. Often you find her around museums… with her secret game: in every museum she imagines going back in time and taking part in the life told by the pieces on display. For this reason Alice learns and observes: she's a curious observer and lets her fantasy free because she wants to gain "familiarity" with the things inside the museum. But look at her carefully… Alice is very near-sighted and when she takes her glasses off… she sees everything foggy! So she wants you to help her observe and resolve a number of strange doubts. Will you help her?

Bobby Jones in search of clues

Bobby Jones, known as B.J., is 10 years old. He is Alice's American cousin and like everyone in the family he too has an obsession: he thinks he's an archeology investigator. So that's why you find him in museums, always searching for clues and mysterious details. Who knows what B. J. has in mind? Maybe he has a secret plan and to carry it out he is looking for adventurous and curious collaborators just like him. What do you think? Do you feel up to it? Try it out!

You will get some special points: a dove is worth 10 points, a fish 5 points and an anchor 1 point. Add them up at the end of the tour and then read your profile.

The Pio Christian Museum

You are in the Pio Christian Museum in the Vatican. The museum is named after Pope Pius IX who initiated the colletion of early Christian artifacts in 1847. Everything you will see will take you back in time, to the III, IV and V century A.D., among the mysterious burials of the first Christians. And their sarcophagi will tell you so many incredible and adventurous stories. Look, "listen" and set your imagination free.
Alice and Bobby Jones will accompany you... but not on their own!

An extraordinary apparition

Observe with Alice
As soon as you enter, there are many fragments of a sarcophagus on the left wall: there are various scenes which represent the Epiphany. For Christians, the Epiphany is a significant moment, tied to the birth of Jesus and it's the story of an extraordinary apparition... Do you know which? At that time, in a faraway corner of the East, a star appears. Three Wise Men discover it, they follow it and arrive in Bethlehem. Here they stop at the manger of the Child and offer him precious gifts: gold, incense and myrrh. Those Wise Men are the first foreigners to meet Jesus.

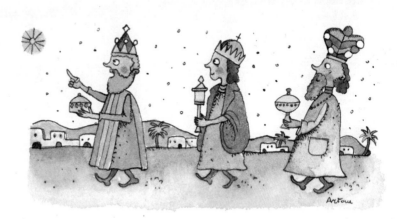

Alice's doubt
Always choose an answer and check on page 57
What could this myrrh be?
a. cottage cheese with honey
b. sweet-smelling resin
c. an old embroidered vest

Go exploring with B. J.
• Find the ox and donkey next to the empty crib.
• Can you see the famous star? It appears five times!

The flame which doesn't burn

Observe with Alice
A little further on, always on the left, some fragments of various sarcophagi repeat the same scene. Look, look… there are three young men surrounded by flames… What story can this be?
Here we would need Thaddeus, the little ghost of the museum, who is well informed on all the secrets of these rooms. I saw him a little while ago, surrounded by a fog, come out of that stone at the back there… Look carefully… can you see it too?

Thaddeus
Here I am, I am ready to tell you a story about the Old Testament… But don't just listen to it, because it is a symbolic story which, like many others, has a message for you. And you should try to understand it!

Three young Jews, Hananiah, Azariah and Mishael, refuse to adore a gold statue which the king of Babylon has constructed. The furious king, has them thrown into the fire… And here's the extraordinary event: the young men appear to be insensitive to the flames! Instead of screaming… they start singing and an angel of God joins up with them… The king is shocked; then he thinks about it and realises that their faith has saved them. So he orders that they be freed and allows the Jews to practice their religion.

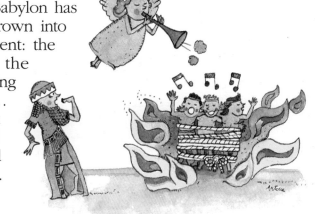

Go exploring with B.J.
- You know, I even found the servants of the king kindling the fire… Find at least one of them!

The sea opens up… and closes

Observe with Alice
Further up, on the right, there's our first sarcophagus with a large scene on its front. Some of the figures are running away… Others are running after them and are swept away by the waves of the sea. Look… one of them is even falling off the horse… But of course! It's the story of the Jews, led by Moses, who are fleeing from their captivity and crossing the Red Sea…

Alice's doubt
I really can't remember… Who's running after them?
a. the Egyptians
b. the Romans
c. the soldiers of Napoleon

Observe with Alice

Oh yes, now I remember the whole story! Can you see it? As written in the Old Testament, the waters open up to let the Jews through on dry land. On the right, the first character is Moses, now safe, who extends his arm on the sea… so the waves close up and sweep over the army of followers. There's also a woman, the prophetess Mary. She is holding a strange musical instrument (the cymbal) which she plays during thanksgiving songs and dances. The story ends with a child and a man. Behind the fleeing Jews the walls of a city can be seen easily.

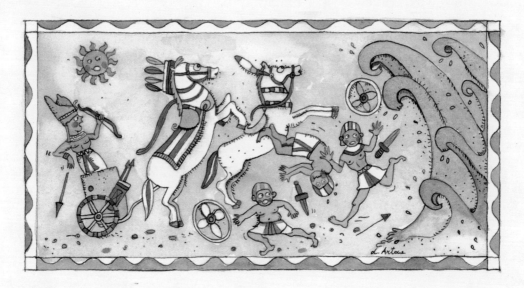

Go exploring with B.J.
- I've found two wheels and 7 shields… Can you find them too?
- Find the pharaoh, standing on a war cart.

A dubious Roman, two meek lions and many winged geniuses…

Observe with Alice

Now go up the stairs. On the right you can see the copy of a very famous two register sarcophagus which belonged to Junius Bassus. You know, he was an important official: the prefect of Rome. And you can tell! Just look at the wealth of his sarcophagus… Look at how many architectural elements on the front of the sarcophagus separate the various scenes: small columns with

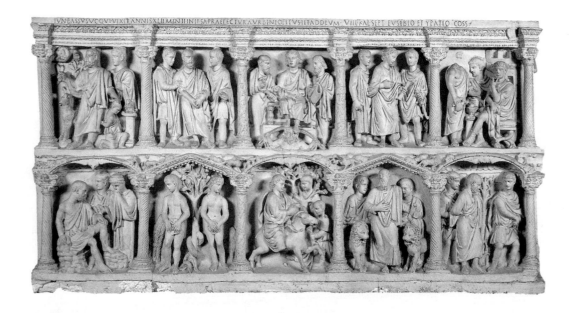

decorated capitals, whole arches, broken arches…

The sarcophagus tells the story of many episodes of the Old and New Testament. Among the characters, Jesus is unmistakable: standing, sitting, on the horse. But always young, without a beard, with curls down to his neck and the same facial features.

37

Alice's doubt

The last two scenes above on the right represent Jesus between two soldiers who are taking him before a mysterious character dressed like a Roman. The figure, sitting beside a small low table, is holding his chin with his thumb and has a dubious air... just like me! Who could he be?

a. Pontius Pilate

b. a soldier at the tavern

c. emperor Tiberius at the barber's

Go exploring with B.J.

- Can you see where Jesus is sitting between Peter and Paul? I'll give you a clue: his foot is on a large curly head... which represents the celestial vault!

Observe with Alice

Below on the right, look... there's a bearded man between two lions. And he doesn't appear to be very scared... Who could it be? Maybe Thaddeus knows something about it...

Thaddeus

And you doubt it? It's a famous story from the Old Testament...
The scene takes place in Persia and that figure with the beard is the Jew Daniel, a man faithful to the king. The king is called Darius and he is honoured by his men like a deity... to the extent that he has just signed a law: anyone who venerates another God will be thrown into the lions' den. But one day Daniel himself is found praying to God.

Some envious spies immediately tell the king. And Darius, is reluctantly forced to throw him to the lions. But here is the miracle: those beasts become as meek as lambs and Daniel is saved! And so, even Darius recognises the power of God, frees Daniel and sends the spies into the den... And the lions have breakfast!

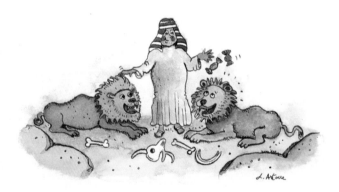

Observe with Alice
Look at all the shoe models that are represented on this sarcophagus. Do you feel like copying one?

Go exploring with B.J.
On the sides of the sarcophagus I've made a funny discovery: many winged geniuses with capes, they are small and round, look very busy: they harvest, reap wheat and go hunting. I think they must represent the seasons...

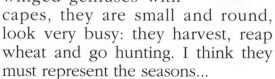

- Can you find the symbols for autumn and summer?
- Find the pumpkin.

Mysterious letters... in a wreath

Observe with Alice

Behind on the left, there's a sarcophagus from the catacombs of Domitilla. Let's look for it together: in the middle of a large wreath, there's a strange symbol which you will see many times in the museum. Here you can see it between two doves on the arms of a cross. Can you see it? It looks like a crossing of mysterious letters...

Alice's doubt

They've told me that the symbol is called a "monogram of Christ" because it represents the first two Greek letters of the name Χριστός (read *cristòs*). It's the name given to Jesus. Can you help me remember its meaning?

 a. king of the Jews
 b. anointed, chosen by God
 c. crucifix

Observe with Alice

The sarcophagus is the story of a few moments of the Passion of Christ and the small scenes are like illustrations which make up a story. Look at them with me: here's a young man carrying a cross on his back; and Jesus receiving the crown of thorns on his head; then still Jesus being escorted by a soldier; and finally Pontius Pilate, dubious as usual... Now, if you're the tidy type, help me put the various scenes in order... According to the way the events took place, which is the first, the second, the third and the fourth?

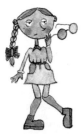

Alice's doubt

Do you remember? You've just seen the scene of Jesus and Pilate on the front of the sarcophagus of Junius Bassus. Now compare it with this one... You see? The two scenes appear to be very similar and so do the characters! I've noticed that this happens a lot... can you help me remember why?

a. because the scenes are symbols, which transmit the same message
b. because the photo of Pilate had appeared on the newspapers of the time
c. because the scenes which are similar are all the work of the same sculptor

Go exploring with B.J.
• Where do you see this character?

Alice's doubt

Why could it be that still today when we don't want to take a decision we say «I wash my hands of it»?
a. because cold water stimulates ideas
b. because the phrase derives from a famous gesture by Pilate
c. because those of ancient times believed that dirty hands led to wrong decisions

Four men in a boat

Observe with Alice

Here, on the right of the sarcophagus of Junius Bassus, there's a fragment with four men in a boat. Who could they be? It's Jesus with his Evangelist companions. Their names are written in red: John (it's incomplete), Luke, Mark...

Alice's doubt
Maybe one is missing... Who is the fourth Evangelist?
a. Matthew
b. Peter
c. Lazarus

Observe with Alice
Look, look... There are waves, the companions row and Jesus leads the boat. But his hand is too large to be a simple hand... surely there's a hidden meaning! That's right, that boat could represent the Church: Jesus is the captain and the Evangelists are the crew. And this is how we explain the mystery of the large hand: a safe leadership, despite the difficulties...

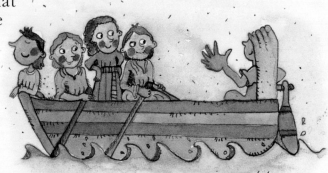

A terrible sacrifice!

Observe with Alice
Just before the stairs, on the right, there's the mould of a sarcophagus divided into seven scenes. It tells so many stories!... Look at the first on the left: a bearded man with a sword is leaning his hand on the head of a boy on his knees. I wonder who these two characters are? Thaddeus reveals it to us...

Thaddeus
The characters of the Old Testament: Abraham and his son Isaac. Imagine! God spoke to Abraham and made a terrible request: he must give his son to him in sacrifice! Abraham cannot understand why... he doesn't know what to do... and spends sleepless nights tormenting himself. One morning he makes his way slowly towards the mountain, taking Isaac with him. He prepares everything for the sacrifice, he grabs a knife and... when he is about to strike his son, an angel of God stops him, just in time. And so Abraham realises that God only wanted to put him to a hard test; a test of obedience and absolute faith, which exceeds the boundaries of human reason.

Go exploring with B.J.
Dear me! This story makes me shiver. But it also makes me think... But now let's try looking carefully at the scene together. What do you think about going hunting for an important detail? Complete the sentence after observing the scene:
«The angel of God speaks to Abraham; look, look,
strange you can't hear the voice but you can see the...»

Observe with Alice
Now come up the stairs with me. On top, on the right there's another sarcophagus divided into seven scenes by small columns and other decorations. Look at it well and listen to B.J.

Go exploring with B.J.
- Here too find the scene of Abraham and Isaac
- Can you see Adam and Eve?
- And the three young men in the furnace? Be careful:
 this scene is repeated twice!

The first woman and the first miracle

Observe with Alice

On the left, in front of the windows, there is another two register sarcophagus with a large medallion in the centre depicting the "owners", a married couple buried together. That medallion is like the photo of the deceased you see on some graves today.

Here too there are scenes of the Old and New Testament following each other, without small columns or other divisions between the stories. Look above on the left at the three bearded figures: they look alike, one of them is sitting on the throne, another is

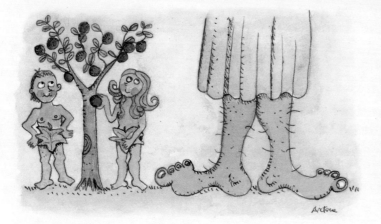

leaning his hand on the head of a small woman; the third is watching… Lying on the ground there's a small man asleep… who looks like a boy. Who could they be? But of course! It's the Father, the Son and the Holy Spirit, who together give life to Eve, the first woman, creating her from the rib of Adam.

44

Alice's doubt
Have you noticed that in this and other sarcophagi there are some very small figures next to other larger ones... I can't understand why...

a. because they are children
b. because they are further away and thus obey the rules of perspective
c. because the size often indicates their importance

Go exploring with B.J.
- On the floor below look for another three nearly identical figures who are bringing gifts... to a famous child. And surely you already know who they are!
- Nearby find a blind man who has been cured by Jesus. I'll give you a clue: he is very small and really needs help.

Observe with Alice
Look carefully above next to the medallion; you'll see Jesus with three small amphoras at his feet and he is touching them with a small stick... What's happening? Let's ask Thaddeus for information.

Thaddeus
A wedding is being celebrated in the village of Canaan. Mary, Jesus and the disciples are among the guests... At a certain point there is no more wine. What can be done? Mary is concerned and asks Jesus to do something to help the groom... So Jesus intervenes: he requests that the amphoras be filled with water and tells the servants to offer them to the guests. How strange! That water has become wine and it is even better than the wine they had been drinking until then...

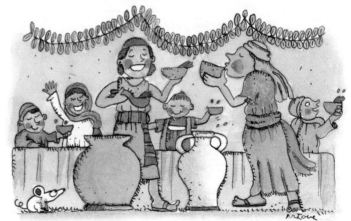

The cockcrow

Observe with Alice

On the right there's a two register sarcophagus, that has a structure like the one just mentioned. In the central medallion, that here has the shape of a shell, you can see the portraits of the two brothers to whom it is dedicated. In this sarcophagus the scenes follow each other without divisions, in a crowd of figures.

But where is that "crowing" coming from? Come on, give me a hand, let's look together! Ah, there it is. Above on the left there's a small cock… You can see it between Jesus and the man with the beard, looking thoughtful. The scene makes me curious… but I cannot remember the event…

Thaddeus

Do you need me? I can explain everything…
The bearded man is Peter and he is so perplexed because Jesus has just made a strange prediction: "Before the crowing of the cock you will renege me three times". What does he mean? Peter doesn't understand, he's confused… But then the prediction comes true. Listen to what happens… When Jesus is arrested and taken by the guards in front of the High Priest, Peter is among those following him. A servant asks him if he is a disciple of Jesus… and he, instinctively, says no. He is scared and doesn't want to be implicated. Later, when Jesus is questioned, someone else asks Peter the same question and once again he says no. But another person insists, saying he had seen Peter in the olive orchard with Jesus. And Peter, even more scared, denies knowing Jesus for the third time. At that precise moment the cock starts crowing…

Go exploring with B.J.
Together let's find other characters which you already know: look for Isaac who is on his knees and Daniel who is worried... They are prepared for death... but their fate will be a different one!

Many small coloured stones

Go exploring with B.J.
- Go forward and on the right look for Flavius Julius and Maria Simplicia. They're a married couple, pictured in small coloured and shining golden stones: the pieces of the mosaic.
- Now compare the woman with the drawing and look for the three mistaken details. Then continue colouring it in...

Alice's doubt
Next to the married couple there's a small mosaic on a brick: it's a small cock... which is pecking something. But I can't really see what...
a. could it be a fig?
b. or a flower?
c. or maybe a Roman frog?

Go exploring with B.J.
- Close by, look for the front of the sarcophagus with two scenes near each other dedicated to Jesus: his birth and baptism. I'll give you a clue: the Virgin is missing from the crib... and Jesus receives his baptism immersed in water.

Alice's doubt

I have a doubt: where are John the Baptist and Jesus in the famous scene of the baptism?

 a. on the banks of the river Jordan
 b. on the shores of the Red Sea
 c. on the banks of the river Tiber

Stories of food, health and life

Observe with Alice

Come with me, further up on the left, between two windows, on a platform, here's the sarcophagus of miracles and healing! In the middle you can see Jesus and at his feet baskets full of... bread loaves. If it's time for your tea... don't let your mouth water but listen with me to Thaddeus' story.

Thaddeus

The scene represents a very famous miracle. One day a large crowd of over 5000 people gathers around Jesus to listen to his preaching. But it gets late and everyone is hungry. What can be done? The disciples check their supplies: they only have five loaves of bread and two fish... And it certainly isn't easy to find food for all those people... But Jesus doesn't lose hope! He blesses the little bread and fish and then asks the disciples to share them out among the crowd... The disciples protest but obey and... incredible but true: everyone has plenty to eat! And that's how the miracle of the bread and fish takes place.

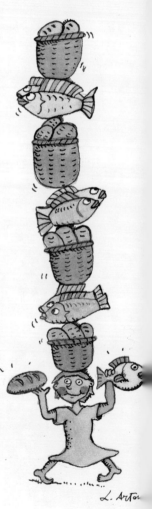

Observe with Alice
Among the scenes portrayed, Jesus cures the blind man and the paralytic. Look carefully: the latter is carrying a small bed on his back, which is now useless to him and starts walking.

Go exploring with B.J.

• Look carefully… close by, always on the left, there's another very similar sarcophagus. Look for it, compare the scenes and find the common characters.

Observe with Alice
Have you found the sarcophagus to compare? Well then look at it carefully: you'll see a small mummy in its tomb, in the shape of a small temple. Jesus touches the mummy on the forehead, while a kneeling woman is at his feet. Who can the two unknown characters be?

Thaddeus
It's not so hard… Don't you know? The mummy is Lazarus, who died four days ago and the woman is his sister Mary, who can find no peace. Jesus' intervention is extraordinary: Lazarus returns to life and this miracle becomes a message of salvation for Christians.

Who embraces the newly-weds?

Observe with Alice
Come down from the platform and look at the centre of this strange two register sarcophagus, which is very different from the others… I can't believe my eyes! On the front, there's a goddess, Juno, the wife of Jupiter, who protects marriage. And indeed she is embracing the newly-weds. But what has a pagan deity got to do with a Christian sarcophagus? Maybe it's a mistake? Well, maybe it's only an example of how some sculptors sometimes mix Christian and pagan elements when they decorate the sarcophagi of their clients.

Alice's doubt

Can you see that strange decoration on the sarcophagus which looks like the waves of the sea? They've told me it's called "strigil"… What a strange word! Where do you think it comes from?

a. from the «strigil», a type of long curved spoon in bronze used by athletes to clean their bodies well
b. from the «strings», sandal laces
c. from the «screams» of clients when they have to pay the bill for a sarcophagus which is too expensive!

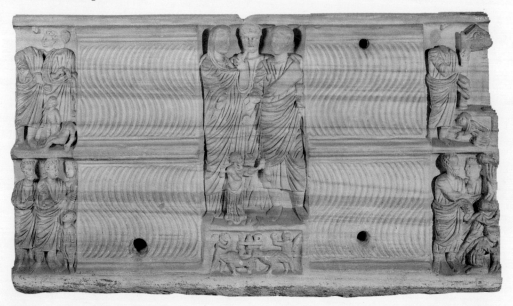

Go exploring with B.J.
• Somewhere there are two small animals. Can you find them?
• Find at least three other "strigilated" sarcophagi.

Among the waves of the sea

Observe with Alice
Move ahead and go up 3 steps. Immediately on the right there's a table engraved in red between four couples of dolphins which swim happily among the waves.

Go exploring with B.J.
- The table is dedicated to a mysterious character... Discover his name.

Alice's doubt
Observe the table with me attentively... it also tells us how old our character was when he died! But I can't read all these Roman numbers properly... Can you give me a hand?

 a. 23 years b. 30 years c. 33 years

Feet and legs for all tastes

Further up, on the right, there's an ancient sarcophagus in the shape of a tub, with two large rams on the sides, in a symmetric position. Poor rams! They seem to hold all the weight of the lid.

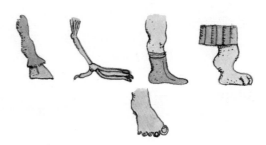

Go exploring with B.J.
- How many feet! Find them on the front of the sarcophagus. But careful: there's an intruder!

Alice's doubt
What is the woman sitting down holding?
a. the broken leg of a stool
b. a closed fan
c. a roll, that is an ancient book

In the stomach of the sea monster

Observe with Alice
A little further up, on the left, there's the front of a sarcophagus with a large boat: its sail interrupts the division into two registers of sculptures, which tell various stories of the Old and New Testament. But the dominating story is that of Jonah which takes place in three successive episodes. They've told me that Jonah had a really strange adventure and spent three nightmare days... but what could have happened to him? Here's Thaddeus who knows everything...

Thaddeus
It's a long story you find in the Old Testament.
One day God orders Jonah to go to the city of Nineveh to tell its wicked and corrupt inhabitants to change their ways. Jonah goes, but no one listens, and, disappointed, he decides to go away. He boards a ship without telling anyone. Suddenly a huge storm breaks out: all the sailors ask the deities what's happening. They reply that there's a stowaway on board who is responsible for the storm. So Jonah is discovered and immediately understands it is a punishment from God.

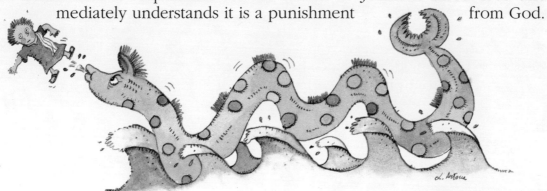

So, to save the others, he asks to be thrown into the sea. Immediately the sea calms down, but poor Jonah is swallowed by an enormous sea monster… In the stomach of the monster, Jonah prays for three days and three nights and pledges obedience to the Lord: he will go to Nineveh to carry out his mission…

Alice's doubt
How is that poor Jonah going to go to Nineveh if he is still in the stomach of the monster?

Thaddeus
Well, thank God, the monster opens his mouth and spits Jonah out onto the shore. That's how he manages to go to the corrupt city and threaten its inhabitants with a terrible divine punishment! Everybody in Nineveh become scared; they pray, repent and the Lord forgives them. Then he makes a little tree appear next to Jonah, so that he'll be able to rest in the shade… Of course that's not the end of the story; but this is the part that is shown on our sarcophagus!

Go exploring with B.J.
What an adventurous story!… Let's immediately start looking for an interesting clue…
• Can you find these three details?
• Discover Jonah during the three moments of the story.

Alice's doubt
Listen, listen… this story is not new to me… Where have I read a similar one? I can't seem to remember the title of the book…
a. Twenty thousand leagues under the sea
b. Pinocchio
c. Moby Dick

Let's go harvesting!

Observe with Alice

In front of Jonah's sarcophagus, look at that beautiful country scene! Three pastors, dressed in short tunics and shoes, are carrying sticks and knapsacks. The middle one has a beard and a ram on his back; the two pastors on the sides are well shaven and are carrying sheep. All around there's a crowd of geniuses who are busy with the various activities of the harvest.

Go exploring with B.J.

• Yes, now I'm really having fun! There's so much to do here... read and find the four characters in the song below:

«A little genius with a basket
which he passes to his neighbour
and another little cutie
pressing grapes inside a tub.

Look, look, a little rabbit
squatting in a little corner,
and another jolly genius
is milking a happy goat».

• Here's a drawing by Alice which reproduces a detail of the harvest. But as she can't see very well and she's a little absent-minded, she's made three errors. Find them.

If one sheep is lost...

Observe with Alice
On the left, in front of the glass door, there's a very famous little statue which has become an important symbol for the first Christians: it's called «The Good Shepherd». The image makes you think of Jesus, who loves and looks after his flock, that is all men.

You know, this statue was found in the corner of a sarcophagus: it was a high relief, which was then detached. It represents a young shepherd without a beard, with long curly hair; he is wearing a short tunic and is carrying a lamb on his back, with a nice woollen coat which seems to be really soft.

Look with me. At very bottom, on the tunic there's a strange opening: it's the sign of a repair job which (in the 18th century) completely renewed the hem of the tunic and the legs of the pastor.

Alice's doubt
What would you do if you had 100 sheep and you realised that one was left out of the flock and had got lost who knows where?

a. you'd leave the 99 and go and look for it
b. you'd leave the lost sheep to its fate so as not to abandon the others
c. you'd sleep over it and leave the decision to the following day

If you don't know what to answer, read the Gospel of Luke, chap. 15, verses 4-7, which tells the parable of the lost sheep.

Observe with Alice

Here's the photo of another statue of the Good Shepherd, which you will see further on, right at the end of the tour. Compare the two and look for the differences. Found them? You'll be able to check them observing the original.

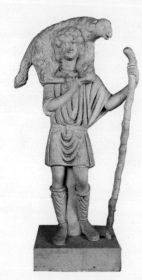

Go exploring with B.J.

- Along the glass passage, look for at least five images of the Good Sheperd.
- Next to one of the images of the Good Sheperd there's a hut like this one. Find it.

Mr. Severe's job

Observe with Alice
Now walk along the passage right to the end. Next to the large statue of Hippolitus, there's the stone of an ancient Christian tomb, dedicated to Mr. Seberus (Severe). This inscription is very simple… but it suggests something to us. Look at it with me.

Alice's doubt
From a clue we can discover Mr. Severe's job when he was alive. Which one of these three was it?

a. tavern-keeper
b. basket-maker
c. perfumer

Alice and B.J. have reached the end of the tour. They're a little tired but their eyes and minds are filled with images, voices and adventures which they weren't aware they could discover among these ancient stones. The atmosphere of the museum is always magic and a little mysterious…

Thaddeus has vanished into thin air. Maybe he is crouched up in his fog, behind some slab or beneath a sarcophagus. He is patiently waiting for another curious boy like you to reveal to him the secrets of the ancient Christians and the interesting stories of their great book.

Now that your tour is over and your friends have left you alone, there's still something you must do: add up the points you obtained during the tour and then go to page 58 to read what sort of «visitor» you are. What do you say?

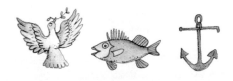

Read your profile

From 150 to 100 points:

Brilliant score! Your friends are proud of you! You're a fantastic observer, you have a lot of patience, intuition and aesthetic sense. Bobby Jones names you «friend of archeology».

From 99 to 50 points:

You like to look around... but not too much. Sometimes you're absent-minded, maybe because you have a lot of imagination which takes you faraway... But you are happy, sociable and everyone is your friend. Even Bobby Jones who appoints you his "reserve assistant".

Less than 50 points:

So so... but don't get discouraged! Maybe you prefer the mysteries of nature to those of archeology: everyone has his own inclinations! But Bobby Jones gives you some advice: if you feel like trying again, repeat the tour... you'll see that the second time round will be easier!

Solutions and answers

The fun pages (pages 30-31):

1) A = b) - B = a)
2) The anchor and the fish
4) 1. Peacock - 2. Jonas - 3. Crucifixion - 4. Polytheism = PAUL
5) a) the drawing reminds us of Nero and the fire of Rome, which the emperor attributed to the Christians
6) a)
7) check the arrows on page 10: if for example you were born in 1988, according to the Roman calendar you were born in (1988 + 753 =) 2741, starting from the year of the foundation of Rome
8) "catacombs" and "sarcophagi"

Alice's doubts (pages 34-57):

An extraordinary apparition: page 34, b.
The sea opens up... and closes: page 35, a.
A dubious Roman...: page 38, a.
Mysterious letters...: page 40, b. - page 41 (top), a. - page 41 (middle), b.
Four men in a boat: page 42, a.
The first woman...: page 45, c.
Many small coloured stones...: page 47, a. - page 48, a.
Who embraces the newly-weds?: page 50, a.
Among the waves of the sea: page 51, c.
Feet and legs...: page 52, c.
In the stomach...: page 53, b.
If one sheep is lost: page 55, a.
Mr. Severe's job: page 57, a.

Tipografia Vaticana